DIRECTOR'S CHOICE
FLINT INSTITUTE
OF ARTS

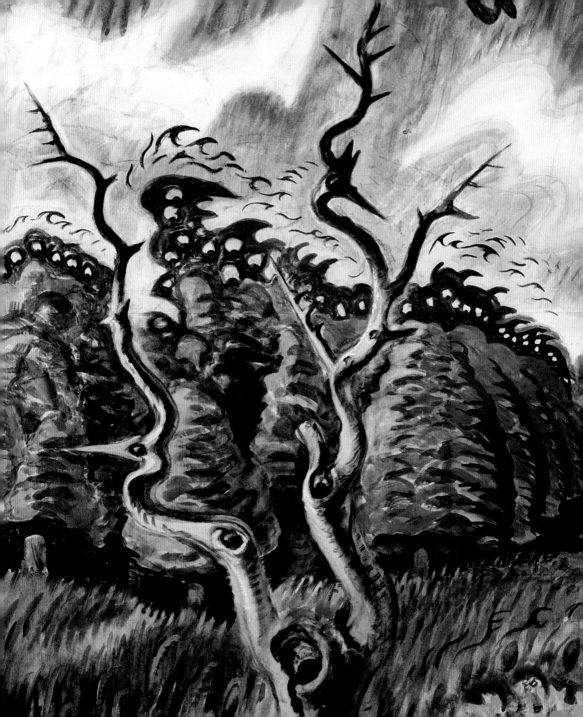

FLINT INSTITUTE OF ARTS

Tracee J. Glab

SCALA

INTRODUCTION

THE HISTORY OF THE FLINT INSTITUTE OF ARTS (FIA) is rooted in education, and it is at the core of everything we do. Founded in Flint, Michigan, in 1928 as a community art school, the FIA began collecting art a year later and broadened its mission to teach art through exhibitions and programs, in addition to hands-on learning in a studio setting. The city of Flint had long been a town of creators and innovators, making the FIA a logical outgrowth of the spirit of the community. The FIA had an early peripatetic existence, moving four times before settling in the current location in the Flint Cultural Center in 1958. While here, we have increased the size of the building seven times to accommodate the growing collection and to serve more people, but our mission has not changed. The Art School is still our heart, offering courses to students of all ages and skill levels.

During the past nine decades, the FIA has been fortunate to have the support of people who understand the role that art and education have in improving our lives and our communities. Our first purchase of a work of art in 1929 was funded by a donation box next to the painting (Tunis Ponsen's *The Old Pier*, n.d.), and the many acts of generosity that resulted set the tone for future giving. A walk through our galleries and a glance at our labels and named spaces reveal dozens of individuals and families, many of whom were connected to the automobile industry that shaped the city of Flint. The collection grew exponentially under two directors who collectively served the FIA for forty-seven years: from 1959 to 1980, G. Stuart Hodge, and from 1996 to 2022, John B. Henry. Under their leadership, several major works were acquired or commissioned. Before my appointment as executive director in 2022, I was a curator at the FIA since 2009 and participated in its growth and change, especially in the areas of glass and ceramics, as well as works by African American artists.

Today, the collection consists of around 9,700 objects, representing cultures from around the globe in all media and ranging from ancient

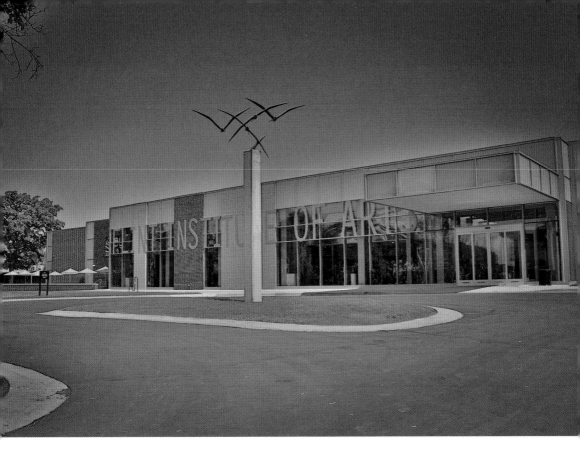

to contemporary. The collection's strengths are its works by American and European artists in painting, sculpture, decorative arts, and works on paper. My selections include well-known and popular highlights but also comprise lesser-known works. Writing this book gave me an opportunity to assemble what could be my own imaginary museum, reflecting what fascinates me. I am most of all drawn to storytelling, the way an object can contain multiple narratives, such as how it's made, what it means, why it exists, and how it came to be in a museum. The stories in the works that follow are some (but not all) of my favorites, and I hope that you enjoy them. Whether in person or online, I invite you to explore the entire collection and find your own selections.

PETER PAUL RUBENS (Flemish, 1577–1640)

Angel, 1610–11

Oil on modern support transferred from wood panel

80½ × 57 in.

Gift of Viola E. Bray, 2005.158

CREATED IN 1610–11 after Flemish artist Peter Paul Rubens returned to the Netherlands from his eight years of artistic training in Italy, this painting was part of a much larger commissioned altarpiece for the Church of Saint Walburga in Antwerp, Belgium. The original altarpiece consisted of several different parts, including Rubens's well-known triptych *The Raising of the Cross* (now located in Antwerp Cathedral).

To fully appreciate this work, you must use your imagination, putting the painting back into its proper context. In its original state, the angel surmounted the altarpiece about thirty-five feet from the ground and was meant to be seen at a distance from below, as if in flight. In addition to the laurel wreath of victory, the angel once held a palm frond, possibly made of metal, both symbols of Christian martyrdom. By painting it on a shaped panel, Rubens aims to break down the boundaries between the natural and supernatural, giving the illusion that the angel is real and is entering our space. This work is also extremely rare, being one of only two surviving examples of Rubens's shaped panel paintings.

I remember when I first saw it, located above the mantelpiece in the Viola E. Bray Renaissance Gallery amidst the *Rinaldo and Armida* tapestries (see pages 10–11), and thought it was some kind of odd decoration. Never did it occur to me that it was originally part of an elaborate artistic installation.

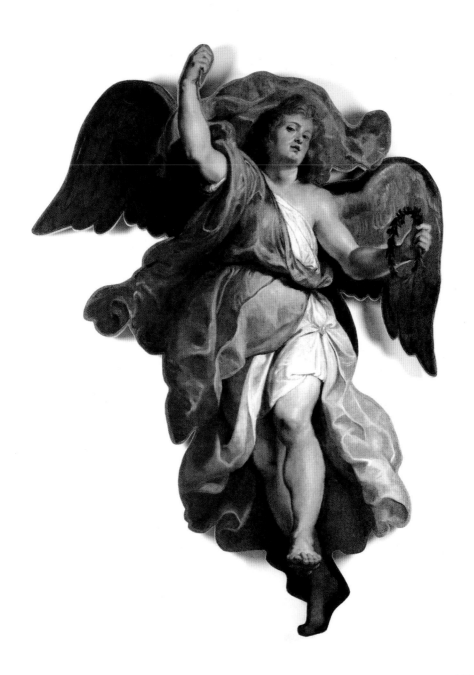

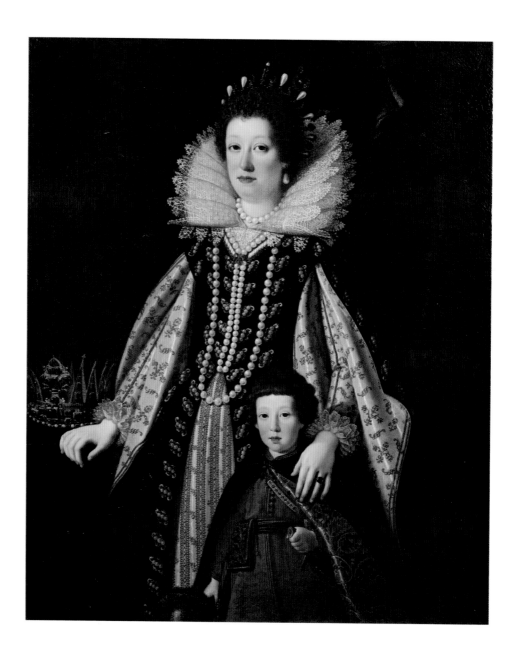

JUSTUS SUSTERMANS (Flemish, 1597–1681)

Maria Maddalena of Austria (Wife of Duke Cosimo II de' Medici) with Her Son, the Future Ferdinand II, 1623

Oil on canvas

56⅝ × 46⁷⁄₁₆ in.

Gift of Mr. and Mrs. William L. Richards, 1965.15

THIS PAINTING EXUDES THE POWER and status of two members of the Medici family, Maria Maddalena of Austria (1589–1631) and her son Ferdinand (1610–1670). Justus Sustermans began this portrait when Grand Duke Cosimo II de' Medici (1590–1621) was still alive but completed it after his death. At age ten Ferdinand was too young to assume a leadership role, so his mother and his paternal grandmother, Christine of Lorraine, served as co-regents until he turned seventeen.

Though the future leader of the family is shown in the front grasping the hilt of his sword, it is his mother who dominates the canvas. Depicted in her wedding dress, awash with pearls and a prominent lace ruff, she anchors the composition, her body forming the bridge between her late husband's crown on the table and her son. Sustermans also employed some creative license, depicting Ferdinand and Maria as much younger than their actual ages. As was a typical custom for royal portraits, this work was copied and circulated to different locations. The original is in the Uffizi Gallery in Florence.

I first saw this painting in 2002 as an undergrad at the University of Michigan Museum of Art, where it was on loan to the exhibition *Women Who Ruled: Queens, Goddesses, Amazons 1500–1650*. I remember how excited I felt learning about powerful women in history, like Maria Maddalena, many of whom have often been overlooked.

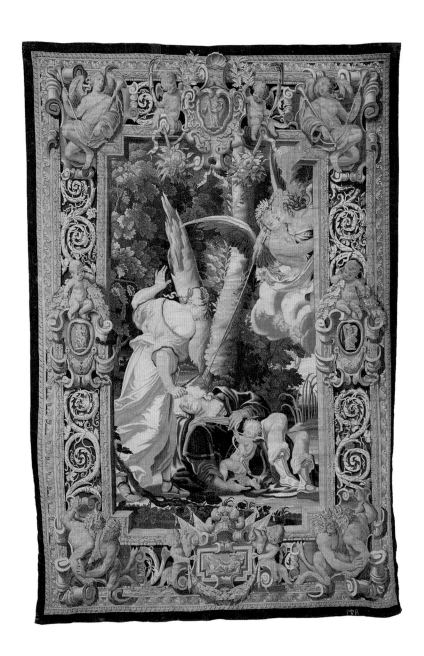

Designed by SIMON VOUET (French, 1590–1649)
Manufactured by RAPHAEL DE LA PLANCHE (French, active 1629–1661)

Armida About to Kill Sleeping Rinaldo, 1633–37

Wool and silk (modern cotton lining)

177 × 125 in.

Gift of Viola E. Bray, 2005.124.1

THIS TAPESTRY PANEL is the first in a set of ten that tells the love story of sworn enemies Rinaldo and Armida. The tapestries were woven in the Faubourg Saint-Germain tapestry workshop on rue de la Chaise in Paris under the direction of Raphael de la Planche after the designs painted in 1631 by Simon Vouet, first painter to King Louis XIII of France. In this work, Armida, a Saracen (an Arab or Muslim) princess and sorceress, is about to kill Rinaldo, a Christian knight, who is in the Holy Land during the Crusades. Before she can kill him, she is shot with Cupid's arrow and instead falls in love.

The tapestries reflect the angst of the Thirty Years War (1618–48) through the lens of another religious war that took place 600 years earlier. In the story, based on Italian poet Torquato Tasso's *Gerusalemme liberata* (*Jerusalem Liberated*), Rinaldo is confronted with the choice between personal love (or lust) of Armida and brotherly duty to king and country. While the choice he makes seems to support his countrymen, in the last panel, he returns to Armida to prevent her from taking her own life.

Viola E. Bray Renaissance Gallery

The objects in the Viola E. Bray Renaissance Gallery, including the Rinaldo and Armida tapestries, will always occupy a special place in my life because I was hired by the FIA in 2009 to work on a catalogue to celebrate the gallery's fiftieth anniversary in 2011. In the late 1950s, longtime Flint resident Viola Bray purchased nearly sixty Renaissance and Baroque works of art and provided the funds to create this special gallery that gives visitors the feeling of stepping back 400 years in time.

Rembrandt Harmenszoon van Rijn (Dutch, 1606–1669)

Abraham and Isaac, 1645

Etching on paper

6 3/16 × 5 in.

Gift of the Whiting Foundation through Mr. and Mrs. Donald E. Johnson, 1970.16

Rembrandt van Rijn is an artist whose works I search for on any museum visit. His images of religious subjects in particular convey a moving image of humanity and spirituality combined.

Taken on its surface, this etching looks like an ordinary conversation between an older man and a younger boy. The title tells us that there is much more going on here. This work depicts the scene of the patriarch Abraham obeying God's order to sacrifice his only son, Isaac. This test of faith is recounted in the Bible book of Genesis. Rembrandt captures the moment when Isaac, faithfully carrying a bundle of branches to burn the offering, asks his father, "Where is the lamb for the burnt offering?" Abraham replies, with his finger pointed to the sky, that God will provide one. Isaac survives—and Abraham passes the test—when the angel of the Lord tells him not to lay a hand on the boy. A ram caught in a thicket by his horns becomes the burnt sacrifice instead.

Rembrandt, who completed more than 300 prints in his life, had a unique ability to capture intense human emotion within a small image with just etched lines. The hand gestures of Abraham, one hand pointing and the other grasping his chest, must reflect his torn feelings: obedience to God or keeping his only son alive. The troubled look on Isaac's face further underlines the charged moment.

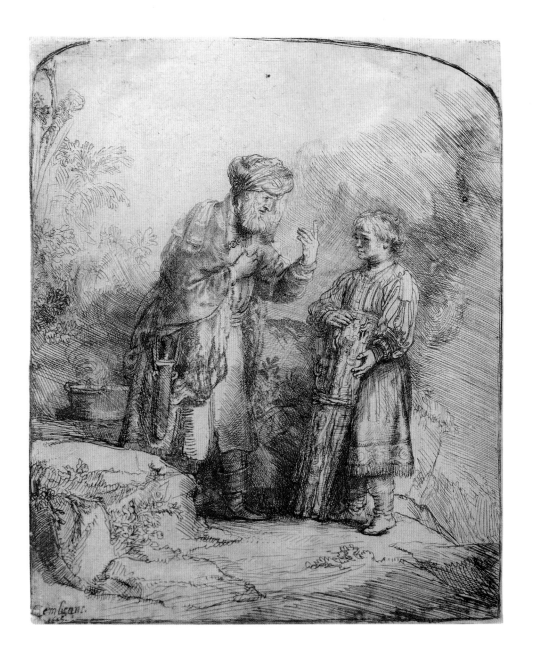

Elisabetta Sirani (Italian, 1638–1665)

Cleopatra, ca. 1662–65

Oil on canvas

37¼ × 29¾ in.

Gift of the Hurand family in memory of Dr. Ben Bryer, 2002.53

Elisabetta Sirani was born in the right place, at the right time, to the right family. She was born in Bologna, the site of the oldest university in Europe and the most important city in the Papal States (modern-day central Italy) after Rome. At this time, Bologna was the leading city in Italy for women artists because education for girls was encouraged, and many university scholars were also art patrons, creating a robust demand for art. Having an artist father was an important factor for the young Sirani: She apprenticed with her father, Giovanni Andrea Sirani, and became a professional artist by the age of seventeen. Known as "the best brush in Bologna," she created more than 200 works before her premature death at the age of twenty-seven.

The majority of Sirani's works were historical subjects, especially images of strong and brave women, like this portrait of the Egyptian ruler Cleopatra VII. Typically depicted as a sexual object, partially clothed or nude, Cleopatra was a favorite erotic subject for Renaissance and Baroque artists. However, in this painting, Sirani portrays Cleopatra not as a femme fatale, but as a virtuous contemporary Italian beauty. This work shows Cleopatra about to dissolve a pearl in a cup of vinegar, based on the story that she made a wager with Mark Antony about who could spend the most money at a banquet. With the value of the pearl estimated at around 420 talents, or $9 million in today's money, Cleopatra won the bet.

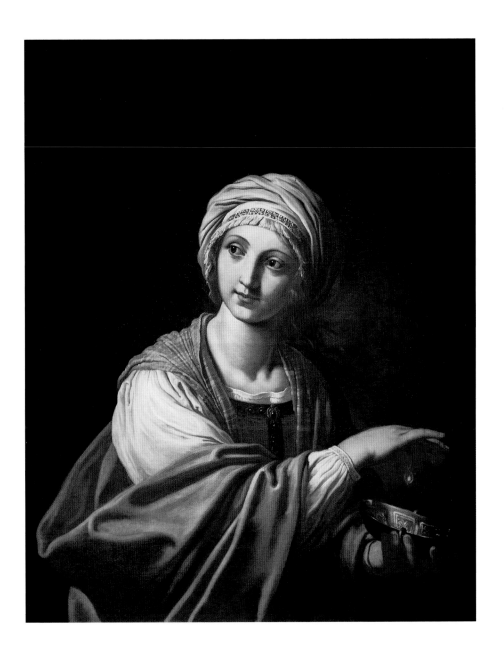

CHINESE ARTIST, Qing dynasty, reign of Emperor Yongzheng (r. 1722–1735)

Bird-Handled Flask, 1734

Porcelain

9 × 9¼ × 5 in.

Gift of Mrs. Thelma C. Foy, 2005.99

ALL OBJECTS HAVE A STORY TO TELL, and many of them have several stories. Stories about how, when, or why they were made, what they meant, how they were used, and—what concerns me most as a museum professional—how did they end up here? I was at first drawn to this object because of its elegant beauty, but upon learning the circumstances about how and why it was made, I became even more intrigued.

To start with when, we know in this case the exact date it was made: 1734. This porcelain flask has a seal on the bottom that translates to: "A new sample made in the 12th year of Yongzheng." This seal makes this work a rare piece—having samples made before they were produced indicates the tight control that Emperor Yongzheng kept on production in the kilns at Jingdezhen, China. Additionally, art of the Qing dynasty often referred to earlier examples from previous dynasties, and this work is no different. It mimics the shape of a bronze wine flask from the Han dynasty (202 BC–AD 9). By employing such tight controls, in both content and style, the emperors used the arts to promote and legitimize their rule.

Another story is how the work came to the FIA. Purchased from Chinese dealer C.T. Loo in Paris, Thelma Foy (née Chrysler) gave the porcelain to the museum along with several other ceramics in 1956. Thelma lived in Flint in the early twentieth century when her father, Walter Chrysler, led Buick. Eventually Walter Chrysler started his own automobile company, and the Chrysler family moved to New York, where he built the Chrysler Building. Thelma kept ties with people she grew up with in Flint, remembering the FIA in her gifts of art.

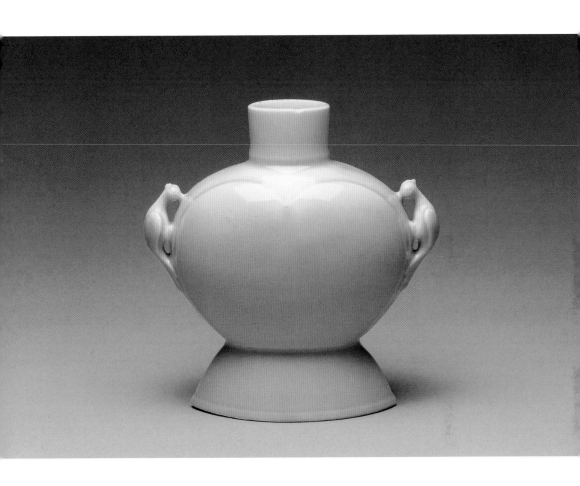

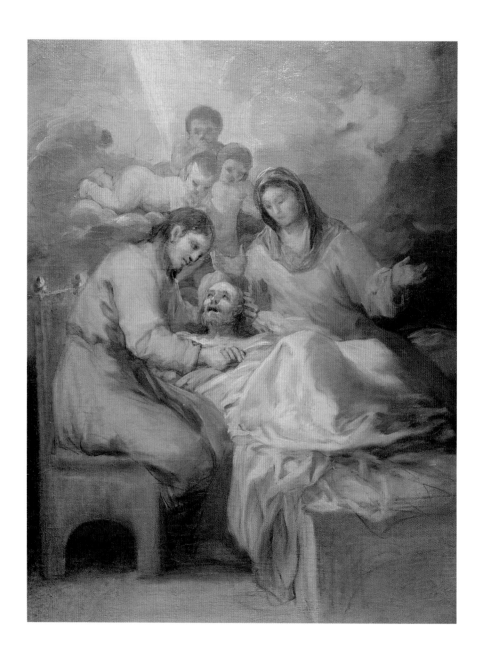

Francisco José de Goya y Lucientes (Spanish, 1746–1828)

The Death of Saint Joseph, 1787

Oil on canvas

21⁷⁄₁₆ × 16³⁄₁₆ in.

Gift of Mr. and Mrs. William L. Richards through the Viola E. Bray Charitable Trust, 1967.19

Commissioned by Charles III of Spain to create three paintings for the Santa Ana convent in Valladolid, Francisco de Goya made this sketch depicting a rare subject in the history of art: Jesus and his mother, Mary, at the deathbed of his father, Joseph. To me, this is the most emotional painting in the FIA's collection. If you take away the cherubs hovering above the Holy Family, you could be looking at any deathbed scene of a parent and adult child. Before our modern age of death in hospitals or hospice centers, most people died at home in their own beds, with friends and family close by keeping vigil. Here, Goya depicts a tender scene, with Jesus cradling Joseph's head and holding his hand. Jesus leans forward, possibly to hear Joseph's last words.

The final painting in the convent is remarkably different from this sketch. Goya moved the position of Jesus from Joseph's bedside to just entering the room, resulting in a more pared-down and restrained image. The emotion is gone. Looking at this sketch in a gallery—something that the artist did not necessarily intend—gives us an opportunity to not only gain insight into the artistic process but also to see the dramatic emotion that Goya might have felt in making the work.

Sir Thomas Lawrence (English, 1769–1830)

Portrait of Elizabeth Williams (née Currie)
of Gwersyllt, ca. 1804

Oil on canvas

16⅛ × 16⅛ in.

Gift of Dr. Jack Willson Thompson, 1988.7

PORTRAIT PAINTING is a time-consuming process, often requiring multiple sittings with the artist before the work is done. Artists like Sir Thomas Lawrence would often do quick sketches of the most important aspect of the portrait—the face—and then execute the other details later. Sketches are an opportunity to learn about the artistic process—it's as if we are with the artist in the studio, peeking over his or her shoulder. In any exhibition, I gravitate toward drawings and sketches because I think they offer a freshness and insight into creativity that is often missing in the finished work.

The sitter of this work is Elizabeth Williams (1782–1850), an Englishwoman who lived in Gwersyllt, Wales, with her husband, John Williams. This sketch can be connected to the finished portrait of her (now in Buenos Aires, Argentina) depicted as Saint Cecilia, the patron saint of music. It was not uncommon for people, especially women, to have their portraits done as saints or allegorical figures. In the finished portrait, she looks up (as in our sketch) toward heaven for musical inspiration. While biographical details about Elizabeth are scant, perhaps she selected Saint Cecilia as her guise because music had a special meaning for her, or she was a musician herself.

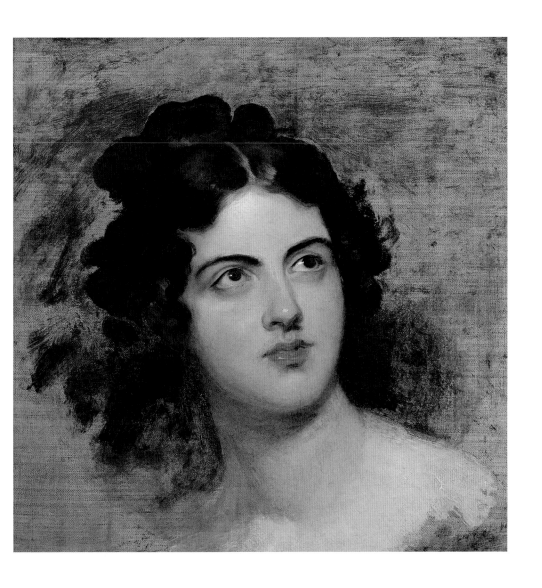

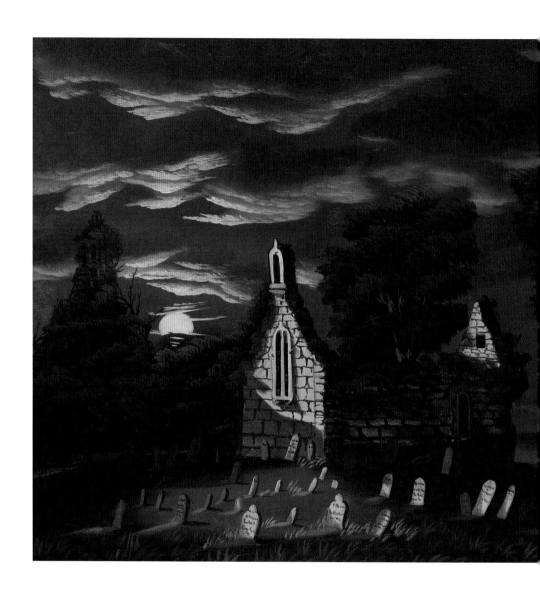

THOMAS CHAMBERS (American, born England, 1808–1869)

Old Sleepy Hollow Church [Alloway Kirk, with Burns Monument], ca. 1843–60

Oil on canvas

18¾ × 24⅜ in.

Gift of Edgar William and Bernice Chrysler Garbisch, 1968.18

IN 2020, WHILE LOOKING FOR A PRESENTATION that would be good for Halloween, I decided to focus on *Old Sleepy Hollow Church* by American artist Thomas Chambers. While doing research, I came across Kathleen A. Foster's book on the artist, which revealed that our painting should actually be titled *Alloway Kirk, with Burns Monument*. Foster showed how Chambers often based his paintings on prints of European locations, in this case a ruined church in Scotland called Alloway Kirk. Additionally, he depicts the monument (on the far left) to the famous poet Robert Burns.

When the work came to the FIA in 1968, it had the title *Old Sleepy Hollow Church*, and it is possible that the donors, Edgar William and Bernice Chrysler Garbisch, bought the work because of its title. The Chrysler family mausoleum is in the Sleepy Hollow Cemetery in New York, and the Garbisches would eventually be interred there. Bernice, like her sister, Thelma, grew up in Flint while their father Walter Chrysler worked at Buick. Bernice and her husband, Edgar, collected thousands of early American, mostly self-taught, artists and donated their works to dozens of museums, including forty objects to the FIA.

Though this is not Sleepy Hollow, the painting is nevertheless spooky. Alloway Kirk is the location of Burns's scary poem about Tam O'Shanter. On the way home from a tavern, Tam stumbles upon a witches' sabbath taking place in Alloway. Though Chambers does not depict a specific scene from the poem, it is clear that he wanted to suggest a haunted atmosphere with the use of a full moon and deep, dark shadows. How artists depict night scenes and the ways they introduce light have always fascinated me. There is also something irresistible to my romantic nature about a graveyard and a ruined church.

CRISTALLERIE DE CLICHY (French, 1837–1885)

Cinquefoil Garland, ca. 1850

Glass

Diam.: 3¼6 in.

Gift of Mr. and Mrs. William L. Richards, 1969.75.152

IN THE MIDDLE OF THE NINETEENTH CENTURY, paper was the primary means of communication, and paperweights were the beautiful accent to this necessity. Presented at the 1851 Great Exposition at the Crystal Palace in London, glass paperweights became instantly popular. The likes of Oscar Wilde and others sought and collected weights made by French manufactories such as Clichy, Baccarat, and St. Louis. Small enough to fit in the palm of one's hand, paperweights reflected the Victorian fascination with miniature worlds magnified.

Weights also became a means of communication in and of themselves, primarily employing the Victorian language of flowers, or floriography, in their decoration. In this language, coded meanings could be conveyed not only by the type of flower but also by its color. A red rose could mean love and passion, whereas yellow meant friendship. In this weight, you can see the signature Clichy pink rose that the manufacturer would often include—pink could stand for pure love or grace and innocence. The center flower is white, meaning purity, with a red interior, which could have indicated true love. Pink, green, and white flowers alternate in a five-lobed garland. Clichy was known for their bright ground (base of the weight) colors, including various shades of blue.

Of the more than 300 weights in the FIA collection, this Clichy paperweight is one of my favorites. The foundation of this collection was a gift of 210 weights from Viola E. Bray, given to the FIA by her son-in-law and daughter, Mr. and Mrs. William L. Richards. Though she bought several works of Renaissance and Baroque art for the museum, Mrs. Bray's personal collecting passion was glass, including paperweights and goblets.

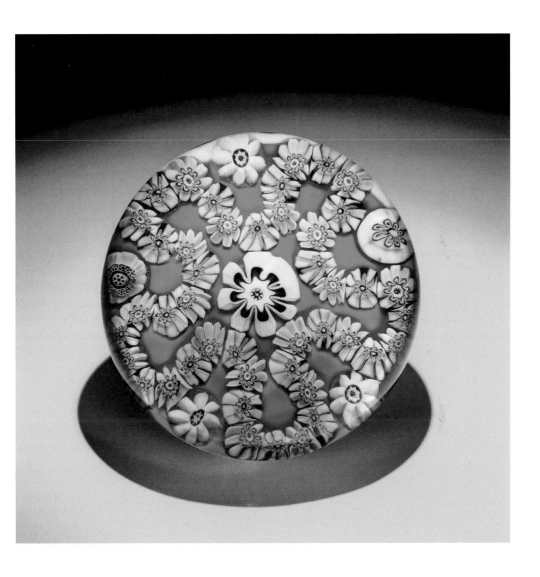

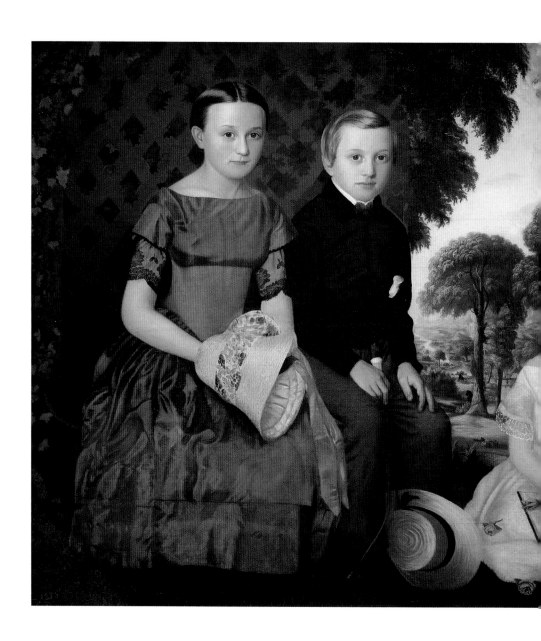

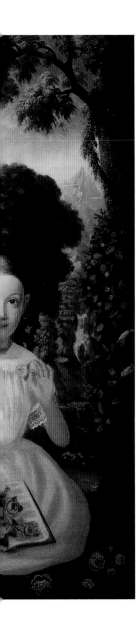

AMERICAN ARTIST

The Fowler Children, 1854

Oil on canvas

49 × 61¼ in.

Gift of the Estate of Mrs. Ernest C. Schnuck, 1976.1

BEFORE MY WORK AS A CURATOR, I used to gloss over portraits in museums, since I did not feel a personal connection to them. Take for example, this simple portrait of three children. It is easy to overlook the significance of this image until you learn more about the tradition of American portraiture at the time it was painted.

According to family records, Gertrude Fowler, the young girl in white on the far right, lived to the age of sixty-one. Her placement and depiction in this painting, however, are reminiscent of early American postmortem, or after-death, portraits. Artists would use visual clues such as roses, dead tree trunks, or departing ships in the background to indicate that the person had passed. Here, the white dress of Gertrude; her separation from her brother, Milo, and sister, Delia; and the scattered roses all seem to point to this conclusion. Gertrude's coral necklace—of the type often hung around children's necks because they were believed to ward off evil—was also a symbol of death, because it was once a living organism that is now rigid, cold, and dead. In addition, the different background that frames Gertrude is an idyllic landscape that seems to suggest heaven. Despite all these clues, there is no conclusive evidence to suggest that there was another family member named Gertrude who died prior to this painting's commission in 1854.

The painting was commissioned by John Nash Fowler, a wealthy ship owner and lumberman from Clayton, New York, who moved to Detroit in 1856. Delia inherited the painting and brought it with her when she moved to Flint in 1871. Her granddaughter, Adelaide Schnuck, donated it to the FIA in 1976.

While we continue to search for evidence, as of this writing, we still do not know the identity of the artist or why Gertrude is depicted in this way.

RALPH ALBERT BLAKELOCK (American, 1847–1919)

A Mountain Road Near Gorham, N.H., ca. 1879–85

Oil on canvas

16 ⅜ × 24 ½ × 2 in.

Gift of Mrs. Jay C. Thompson from the Estate of Mrs. George Crapo Willson, 1969.30

RALPH ALBERT BLAKELOCK'S landscapes are not ordinary depictions—they carry an emotional charge. I am always struck by how his expressionistic brushstrokes seem to vibrate off the canvas. His choice of colors and composition can also make you feel like you are looking at a living thing and not a static image. Although the title indicates a specific place—a mountain road near Gorham, New Hampshire—the landscape hardly seems like anything real in nature. While most of the trees have golden autumn colors, there is one just right of center that still has the vibrant green of summer, shimmering against a gold sky. Nature in the hands of Blakelock is majestic in its potential power, with the tiny figure next to a small house included to communicate scale in this small canvas.

Abandoning an education in medicine to be an artist, Blakelock spent the late 1860s sketching the outdoors in upstate New York and New Hampshire. While initially his style mimicked that of the previous generation of the Hudson River School, in the 1880s he came into his own, creating works like this landscape that would evoke a unique, and sometimes eccentric, vision of nature. Later in life he was institutionalized, following bouts of mental illness and a breakdown in 1891.

This work was donated by Mrs. Jay C. Thompson from her parents' estate. George Crapo Willson was the first president of the board of the Flint Institute of Arts.

Mary Cassatt (American, 1844–1926)

Lydia at a Tapestry Frame, ca. 1881

Oil on canvas
25⅝ × 36¾ in.
Gift of the Whiting Foundation, 1967.32

More than a portrait, this painting depicts a woman in the act of creation. The embroidery that Lydia, Mary Cassatt's sister, is working on is not visible, but we see the intensity of her gaze upon the textile. Her hands are blurrily depicted, in the act of motion, too active to be shown as still. Lydia is absorbed in what she is doing just as Mary must have been, capturing in paint the energy and expression involved in the act of making.

Cassatt, who moved from Pennsylvania to Paris in 1874, was followed soon after by her sister and parents. Lydia assumed a domestic role in the family, freeing her sister to pursue her artistic career. The spheres of influence of most white upper-class women during this time were in the home, where they were encouraged to channel their creative talents into activities like sewing, embroidery, watercolor painting, and music. As the only American artist to be invited to exhibit with a group of French independent artists, later known as Impressionists, Cassatt ventured outside of this sphere but also stuck close to home in terms of her subject matter. Her sister was the subject of dozens of paintings, with this portrait considered to be the last, done a year before Lydia died at age forty-five of Bright's disease, now called nephritis, a degenerative disease of the kidneys.

This important work was given to the FIA by the Whiting Foundation, a charitable trust that was established by Donald E. and Alice D. Johnson, community-minded philanthropists both born in Flint. Donald was a publisher and journalist who started working at the *Flint Journal* and later established the *Flint News Advertiser* newspaper. Their collecting of Impressionist and Post-Impressionist works began in earnest in the 1950s, and in subsequent years, the Johnson family would continue to give gifts through their descendants: Mary Alice, Donald Jr., and Linda.

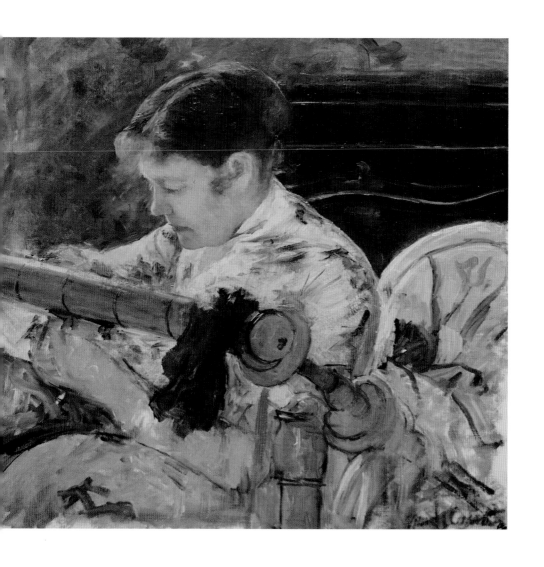

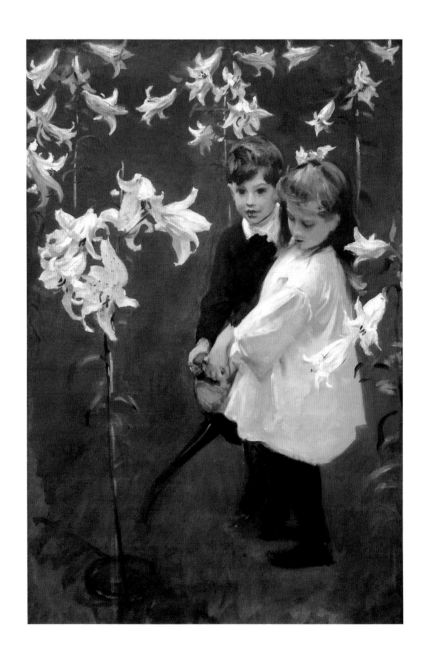

JOHN SINGER SARGENT (American, born Italy, 1856–1925)

Garden Study of the Vickers Children, 1884

Oil on canvas

54½ × 36 in.

Gift of the Viola E. Bray Charitable Trust via Mr. and Mrs. William L. Richards, 1972.47

CREATED IN 1884, after the infamous *Madame X* (now in the Metropolitan Museum of Art, New York) was received with scandal at the Paris Salon that same year, this painting both represents John Singer Sargent's rebound after defeat and demonstrates a period of experimentation. *Madame X*, which depicted American Virginie Amélie Gautreau with the strap of her black gown fallen off her shoulder, offended French society, who denounced Sargent. Later that same year, he left France for England, spending the summer creating portraits for the Vickers family, as well as spending time with collections of Pre-Raphaelite art, including works by Dante Gabriel Rossetti and Edward Burne-Jones, whom he admired. I had always enjoyed learning about Sargent's portraits of Gilded Age society, but when I found out that he was influenced by the Pre-Raphaelites, my chosen subject in graduate school, I was intrigued even more.

This portrait of Vincent and Dorothy, the children of Mr. and Mrs. Albert Vickers, exhibits some of the stylistic aspects of English art to which Sargent was exposed in the summer of 1884. Sargent references one of the signature motifs of the Aesthetic movement with his use of lilies in this painting. He emphasizes the decorative aspect of the lilies, flattening the background with a solid green that eliminates any horizon line. The effect is that of a William Morris wallpaper or Burne-Jones tapestry rather than a three-dimensional garden setting. While this painting was not controversial by comparison with *Madame X*, Sargent used this time to redefine himself as an artist, moving away from a French style to something more English, which would culminate in one of his most beloved works: *Carnation, Lily, Lily, Rose* (1885–86), now in Tate Britain, London.

Rosebud Sioux artist, South Dakota

Blanket Strip, ca. 1885

Bison hide and glass beads

55 × 6½ in.

Gift of Mr. and Mrs. Richard Pohrt, 1985.101

This blanket strip is an amazing technical work of stitchery and bead placement by the Rosebud Sioux, more properly known as Sicangu Lakota Oyate, or Burnt Thigh People, of South Dakota. The colors and geometric shapes are carefully arranged to communicate a powerful message. In Plains art, the circle and the four directions symbolize the sacred center of the world. The blue, yellow, red, green, and black glass beads were imported by Europeans and traded to the Sioux. While the artist is unknown to us now, the skillful bead-work was most likely done by a woman.

Many of the Native American objects in the FIA came from the Chandler/Pohrt Collection. At age fifteen, Richard A. Pohrt met Milton G. Chandler, an automotive engineer, when Chandler moved to Pohrt's hometown of Flint. Chandler collected Native American art and inspired a fascination for the subject in Pohrt. Eventually Pohrt, who later worked at the AC Spark Plug Company, became a collector of Native American art himself. In the 1960s he began buying his friend's holdings, eventually acquiring about 1,500 objects. Some of the objects, like this nineteenth-century blanket strip, were given to the FIA by Pohrt, while the majority of his collection was purchased by or donated to the Detroit Institute of Arts (DIA). One of my first museum jobs was as an intern in the education department at the DIA, researching objects from the Chandler/Pohrt Collection for an interactive database in the gallery.

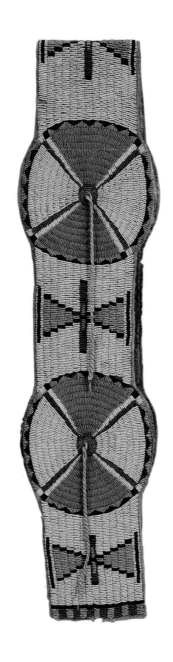

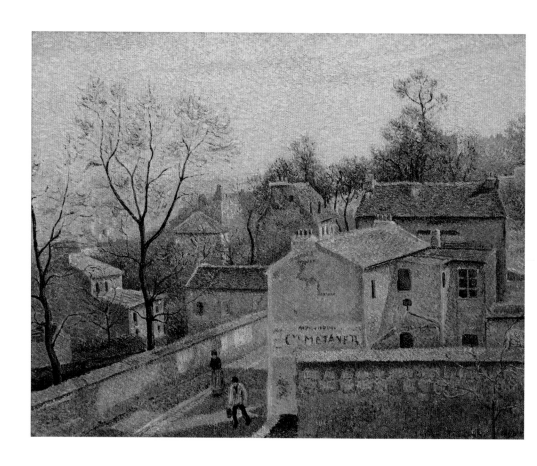

Lucien Pissarro (French, 1863–1944)

Rue Saint-Vincent, soleil d'hiver (Saint Vincent Street, Winter Sun), 1890

Oil on canvas

25¾ × 32 in.

Gift of the Whiting Foundation through Donald E. Johnson, 1979.201

USING THE POINTILLIST TECHNIQUE of dashes of colors, the artist conveys the sense of warmth on a cold day, taking advantage of rare sunshine in winter to depict a street in Paris.

Rue Saint-Vincent, located in Montmartre in the eighteenth arrondissement, was a favored place for artists and writers. In this image, Lucien Pissarro, son of French Impressionist Camille Pissarro, shows us the street from an elevation, looking down on two figures walking up the hill. On the other side of the building, which cannot be seen from this angle, was the famous cabaret Le Lapin Agile, popular with people from many walks of life. I can imagine the artistic discussions that might have taken place there between Lucien and his fellow artists and friends Paul Signac, Georges Seurat, and Vincent van Gogh.

Shortly after this work was completed, Lucien moved to England, where he married English artist Esther Bensusan. Though he followed in his father's footsteps, Lucien would make his own mark in the art world in the UK, becoming a founding member of the Camden Town Group in 1911. In addition to landscape painting, he also illustrated books, created prints, and together with his wife established Eragny Press in their home.

WILLIAM VERPLANCK BIRNEY (American, 1858–1909)

The Reader, ca. 1890

Oil on canvas

12 × 14 in.

Gift of Genevieve and Richard Shaw, by exchange, 2011.317

THIS PAINTING REPRESENTS one of my favorite aspects of museum work: reading. I devour all kinds of art-related texts for research and personal enjoyment: artist's biographies and statements, critical essays, museum labels, and exhibition catalogues, as well as fiction inspired by art or artists.

The questions this work poses may never be answered: Who is this woman? What is she reading? What is her relationship to the artist? Yet, the work can still be enjoyed for what it seems to champion—getting lost in a good book. This well-dressed woman barely knows we are in the room with her, because she is so focused on the pages in front of her.

Despite the small size of this painting, the artist communicates a lot of information about the upper-class status of the woman. She is not in a library, but in someone's—maybe the artist's—home. Large books with fraying pages are piled high on a desk or table; a plant is in the window next to more books that look like they are about to tip over; a calendar is hanging on the wall next to a blue-and-white, possibly Chinese, vase; black gloves, handbag, and fur stole are left on the chair; a glass flute catches the light next to a single red rose. The flower could be a sign that the artist, Cincinnati-born William Verplanck Birney, knows her well, since red roses in the Victorian period were symbols of romantic, passionate love.

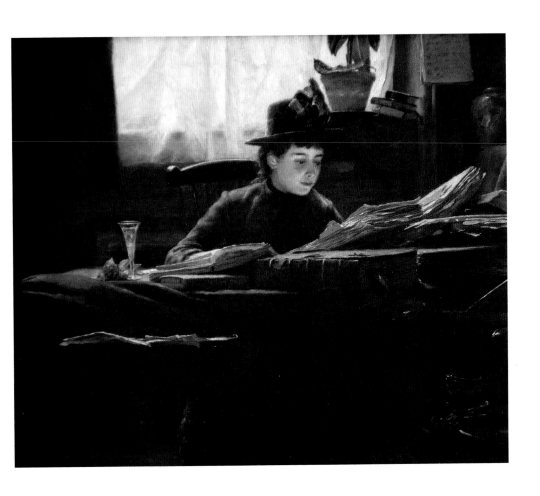

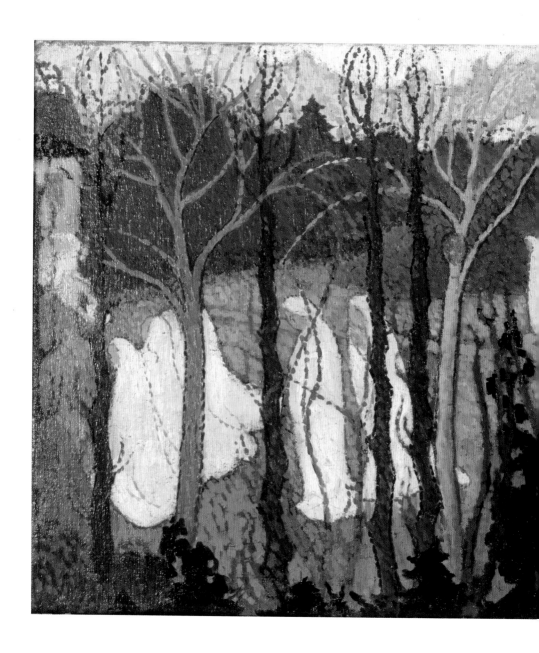

MAURICE DENIS (French, 1870–1943)

Communicants (Spiritual Motive), 1891

Oil on canvas

12⁷/₁₆ × 15⁹/₁₆ in.

Gift of Mr. and Mrs. Martin Ryerson, 1939.8

FRENCH ARTIST MAURICE DENIS created this painting, showing a procession of white-clothed figures in a forest, as a reflection of his Christian faith. The kneeling figures on the far left show their destination: a disembodied hand emerging out of the trees, holding a white oval shape above their heads. The hand is God holding the host, or sacramental bread, that represents the body of Christ during the Eucharist consumed by believers. That this holy ceremony is taking place outdoors in a forest, rather than in a church, deepens the mystery of this scene.

In a larger canvas executed in the same year, titled *Mystère des Paques* (*Easter Mystery*; now in the Art Institute of Chicago), this procession takes place near the entrance to the empty tomb on Easter morning in celebration of the resurrection of Jesus. In the far background of this larger work, Denis depicts a house where he would later live in Saint-Germain-en-Laye, west of Paris. By linking the scene in the Holy Land with the contemporary house, Denis suggests that the ancient faith is still alive in modern times. As part of the artistic group called the Nabis (after the Hebrew word for "prophets"), Denis strongly believed that the artist's "mission is to transform beautiful things into everlasting icons."

Dogon artist, Republic of Mali

Face Mask with Superstructure, n.d.

Polychromed wood

142 × 9 in.

Gift of Justice and Mrs. G. Mennen Williams, 1973.55

Most of the objects you encounter in a museum have been removed from their original context, dislocating meaning and purpose. The works are often aesthetically appreciated, but something is lost without the full framework being disclosed. In the case of this face mask, made by the Dogon peoples in Mali, the towering size and geometric patterns alone impress viewers like me, but it's when you learn about its purpose that you gain a better appreciation for its creation.

This large-scale wooden sculpture is a funerary mask known as *sirige*, or "storied house," used in the Dama ceremony, which honors a deceased elder of the community. Each level, made to look like a traditional Dogon house, represents another generation of the family. A dancer would wear the mask by biting down on the bar in the back of the lowest level and swing his head and body, touching the ground with the top of the mask and bringing it back up to mimic the arc of the sun.

This work was given to the FIA by G. Mennen "Soapy" Williams, the forty-first governor of Michigan, who was elected in 1948 and served six two-year terms in office. Later, as assistant secretary of state for African affairs under President John F. Kennedy, he collected artworks while in Africa, eventually dispersing his collection among the Detroit Institute of Arts, Oakland University, and the FIA.

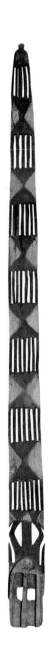

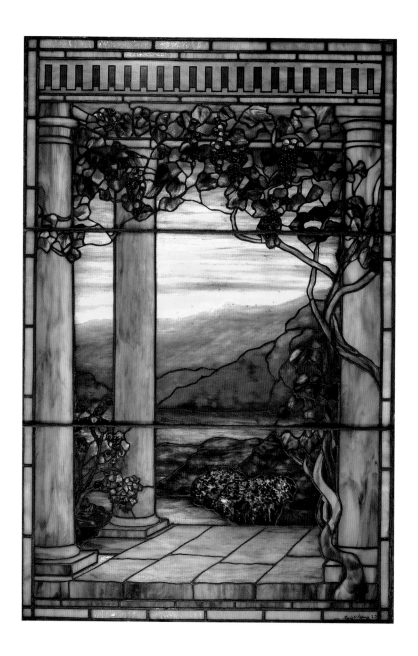

Louis Comfort Tiffany (American, 1848–1933)
Design attributed to Agnes F. Northrop (American, 1857–1953)

Stained Glass Window, early 20th century

Leaded Favrile glass

47⅜ × 31¼ in.

Gift of Fred Bellairs, Robert Bellairs, Mary-Linn Benning, Bill Bishop, Bruce Bishop, Elizabeth Bishop, Falding Bishop, Russ Bishop, Katie Kutschinski, Barbara Miner, Bruce Miner, Doug Miner, Fritz Miner, Beth Osborne, and Barbara Spiess, 2014.35

Louis Comfort Tiffany first pursued his own path rather than joining his father's business, the jewelry and silver firm Tiffany & Company. In a long career, Louis would act as designer and director of his studios, producing decorative arts such as stained-glass windows, home furnishings, and jewelry. In 1902, following the death of his father, he became the first design director of Tiffany & Company.

This memorial window depicts a mountainous landscape seen from the vantage point of a porch with columns. Scholars have attributed the composition design to Agnes Northrop, Tiffany's chief designer, based on her published design *Behold the Western Evening Light*, which appeared in a Tiffany pamphlet on memorial windows in 1896. The window is made of Favrile glass, an iridescent art glass designed by Louis and patented in 1894, notable for its rich, lustrous color.

This stained-glass window was originally installed in the Bishop-Miner mausoleum in Glenwood Cemetery on Court Street in Flint. The family organized the removal of the window for its safety and then donated the work to the FIA. The Bishop name, whose patriarch was banker Arthur G. Bishop, appears on several works of art donated to the FIA.

ODILON REDON (French, 1840–1916)

Apollo's Chariot, ca. 1905–10

Pastel on paper

13 7/8 × 11 in.

Gift of Mr. and Mrs. William L. Richards through the Viola E. Bray Charitable Trust Fund, 1963.4

THIS DEPICTION OF THE SUN GOD APOLLO pulling the sun across the sky looks less like a sunrise and more like a hallucinogenic dream. The bright whiteness of the sun is framed by an intense purple, yellow, blue, and black. The still-life floral landscape in the foreground adds fantastical flair, while Apollo's chariot is pulled across the sky by two horses. This pastel reflects French artist Odilon Redon's unique vision of the world, placing him among the Symbolist group of artists. According to the artist, "My drawings inspire yet cannot be defined. They do not determine anything, like music they transport us into the ambiguous world of the undetermined."

For a large part of his artistic career, Redon made just black-and-white images, but in 1900 he began to use color. He obsessively worked through the theme of Apollo's chariot—creating more than thirty versions of this subject. In addition to being the sun god, Apollo is also connected to music, poetry, and dance. In this version, Redon seems to capture all these aspects of Apollo, using color and line to communicate light, song, and movement.

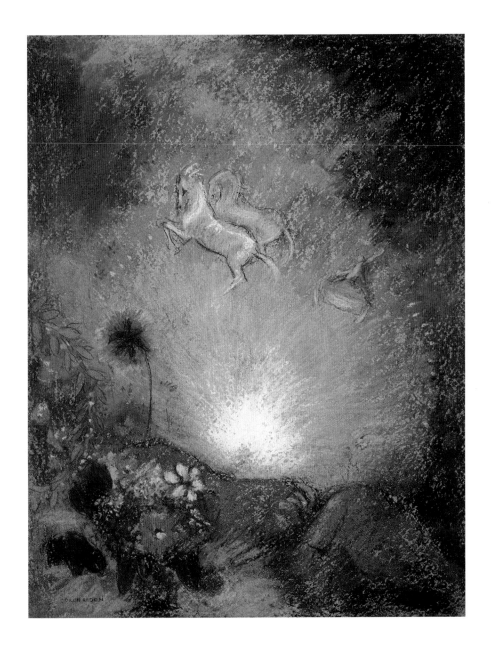

ALEXEJ VON JAWLENSKY (Russian, 1864–1941)

Portrait of Marie Castel, 1906
Verso: Landscape

Oil on board

20¹³/₁₆ × 19⅜ in.

Gift of Mr. and Mrs. Jerome O. Eddy, 1940.8

IN THIS WORK, Russian painter Alexej von Jawlensky creates an icon for the modern age. Similar in size and shape to an icon, the painting is made modern by Jawlensky's use of color and subject matter. The image on one side is a portrait of Marie Castel, created while Jawlensky was visiting Brittany, France, in 1906. She is not a saint, but rather an ordinary young woman. The contrasting colors of orange and blue convey a spiritual sensibility, as if she exists in another plane from us. According to the artist, "I came to understand how to translate nature into color according to the fire of my soul."

Verso

On the back of this object (see right) is a painting of a tree, discovered in 1973 during a conservation treatment. This tree dominates the landscape and reveals Jawlensky's fascination with Vincent van Gogh's work most clearly. It has an energy in itself, giving me the feeling that it could be a window into Marie's soul, a place where she lived or dreamed. In 1936, Jawlensky stated, "My work is my prayer, but a passionate prayer spoken with colors."

This painting was a gift from Jerome Eddy, son of Flint native Arthur Jerome Eddy, in 1940. On a trip to Europe in 1913, the elder Eddy visited Jawlensky's studio and purchased at least nine paintings. Other works he collected on that trip included paintings and sculpture by Wassily Kandinsky and Constantin Brancusi.

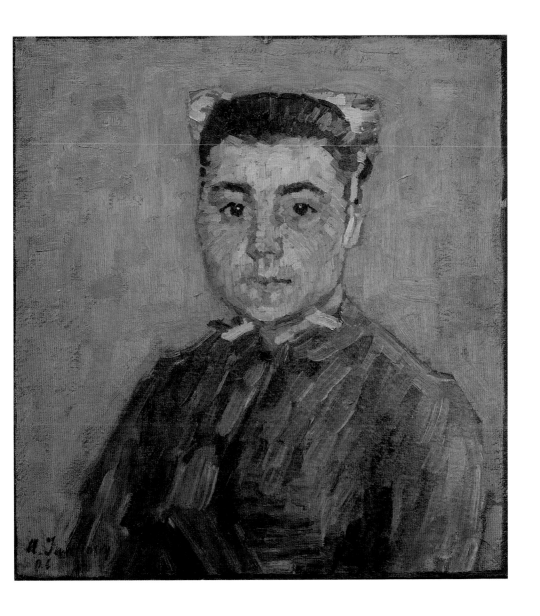

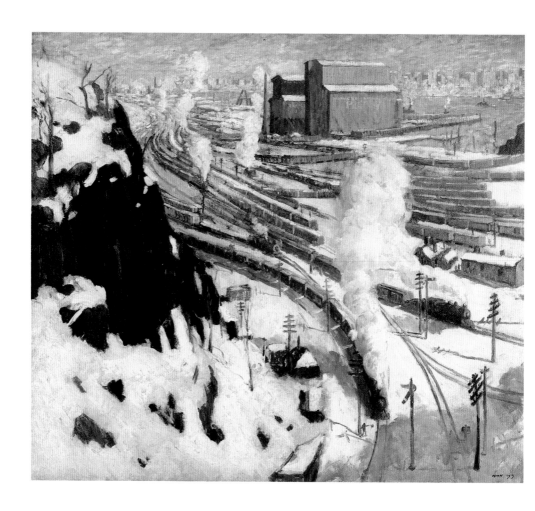

LEON KROLL (American, 1884–1974)

Terminal Yards, 1912–13

Oil on canvas

46 × 52⅛ in.

Gift of Mrs. Arthur Jerome Eddy, 1931.4

IN THIS PAINTING, American artist Leon Kroll depicts the terminal yards in Weehawken Heights, New Jersey, with the Hudson River and Manhattan in the background. *Terminal Yards* was selected for inclusion in the historic International Exhibition of Modern Art, known as the Armory Show, which took place in New York in 1913. Though this work may not look particularly modern to us today, in its time the chosen subject and method of depiction would have signaled modernity. Painted on location on Christmas Day, Kroll captures the immediacy of the winter industrial scene: we can almost feel the cold and smell the coal smoke. Additionally, I like the way Kroll framed the image, showing the towering Palisades on the left, reminding us how nature exists alongside manmade industry.

One of two works purchased from the Armory Show by Flint native Arthur Jerome Eddy, this painting was given high praise by President Theodore Roosevelt who, after viewing the exhibition, called it "one of the most striking in the show." Eddy, who was born in Flint but made his home in Chicago, was one of the earliest collectors of modern art in the United States. In addition to being a lawyer, Eddy also wrote art criticism and traveled to Europe to buy avant-garde artists. He was among the first in America to collect Wassily Kandinsky and works of German Expressionism.

CHARLES E. BURCHFIELD (American, 1893–1967)

Nighthawks at Twilight, 1917–49

Watercolor on paper
34⅜ × 48½ in.
Gift of the Viola E. Bray Charitable Trust, 1964.3

THIS WORK EXEMPLIFIES the eccentric artistic vision to which I am drawn. American artist Charles Burchfield stands out among his artist peers in the twentieth century, creating works that defy categorization and exemplify a unique style. Burchfield began this large watercolor in 1917, his so-called golden year, when he created around 200 works. It depicts a scene from nature in the way only he can, with waves of foliage and trees undulating across the paper, topped by nighthawks dancing in a twilit sky. He returned to the watercolor more than thirty years later, completing it in 1949.

There are elements of the watercolor that look almost surrealistic, such as Burchfield's staring-eye motif that outlines the tops of the trees. For all the looking we do at this landscape, it's as if the artist wants us to know that we are being looked at as well. The nighthawks may be the most realistically depicted, with their white wing patches and aerial acrobatics. Burchfield wrote of the nighthawks, "I love to see them frolicking in the vanguard of a storm. I think they must use the swirling eddies of wind as we do sliding places. How I envy them …" and "That … is what I would do if I could fly." Growing up in Detroit, I loved going up north to the woods near the Upper Peninsula and Lake Huron. For me this work evokes some of my childhood memories of those visits, capturing my feelings for nature: simultaneous fear and attraction.

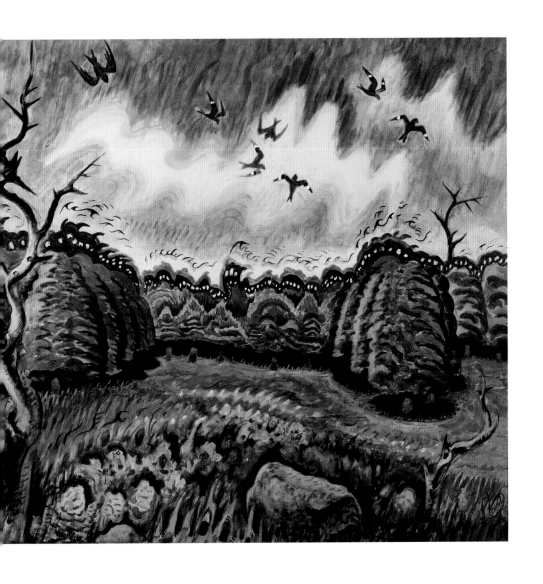

ÉDOUARD VUILLARD (French, 1868–1940)

Madame Vuillard Lighting a Mirus Stove, 1924

Oil on paper mounted on canvas

25 × 29¼ in.

Gift of the Whiting Foundation through Mr. and Mrs. Donald E. Johnson, 1971.12

ONE OF THE THINGS I HAVE LOVED TO DO in my museum work is visit artists' studios. There you see works in progress and materials they have on hand to use or inspire them in their creation. In this painting, we not only get a glimpse of French artist Édouard Vuillard's studio but also a depiction of his most important inspiration: his mother, Madame Marie. According to Vuillard, "Maman is my muse," and his more than 500 paintings of her support this statement. Here she is seen four years before she died, lighting a stove in their home on the rue de Calais in Paris.

The painting has an odd, unsettling quality that makes you feel like an interloper in the scene, even though you have been invited in. The life-size Venus de Milo plaster cast seems like it is about to fall off the mantel, and the view is tilted at a slight angle. The empty chair and easel on the left indicate the artist's presence, but he is absent. But if the easel is empty, where is the work we see being made? The artist most likely took a photograph of this moment and painted it later.

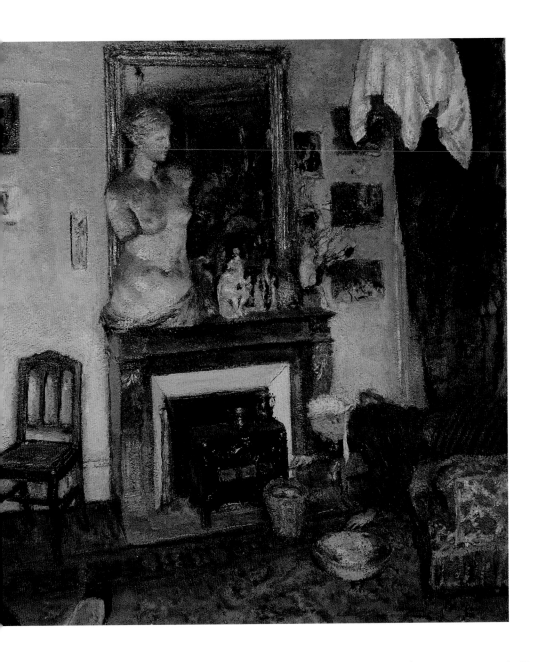

LUCIENNE BLOCH (American, born Switzerland, 1909–1999)

Progress, 1935

Woodcut on paper

13 × 10 in.

Gift of Mr. Jack B. Pierson, 1993.14

IF YOU SEARCH FOR LUCIENNE BLOCH online, you will find she is well-known for taking photographs of her friends and fellow artists Diego Rivera and Frida Kahlo. In particular, Bloch took the only photos of Rivera's destroyed 1933 mural for the Rockefeller Center in New York. But Bloch was an artist in her own right, creating murals and prints that gained her national and international acclaim. This print was created in 1935, shortly after she worked with Rivera on the *Detroit Industry* murals in 1932–33, and a year before she married artist Stephen Pope Dimitroff, Rivera's chief plasterer. Lucienne and Stephen ended up in Flint, where she taught at the FIA's Art School from 1941 to 1945.

This work depicts cornstalks amidst the high-voltage power-lines that dominate the image. In a later state of the print, also in the FIA's collection, Bloch shows two adults and a child walking in the foreground, barefoot and wearing torn clothing. It's clear in the second state that she meant the title *Progress* as sarcastic comment on the plight of workers at the mercy of powers beyond their control. During their time in Flint, her husband was a union organizer, and she photographed labor strikes for major publications.

This work was given to the FIA by Jack Pierson, a native of Flint and employee at General Motors during the early twentieth century. Over a period of years, Pierson gave 924 works to the FIA, representing the largest gift that the FIA has ever received. He was passionate about prints, and his collection dealt with major social issues of the century, such as workers' rights, feminism, poverty, war, civil rights, and the AIDS epidemic.

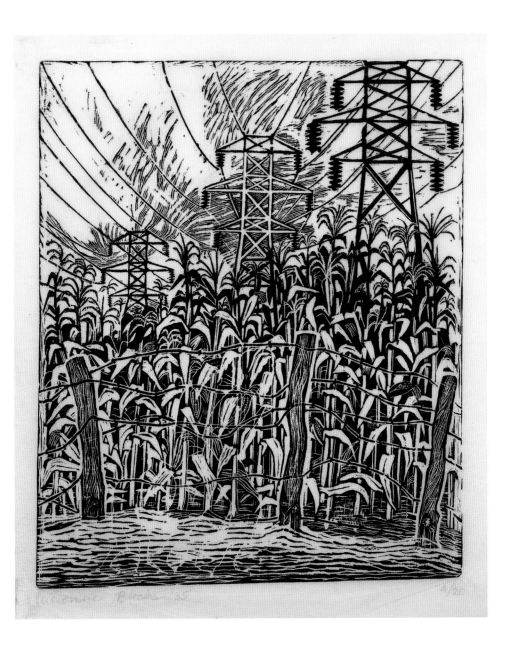

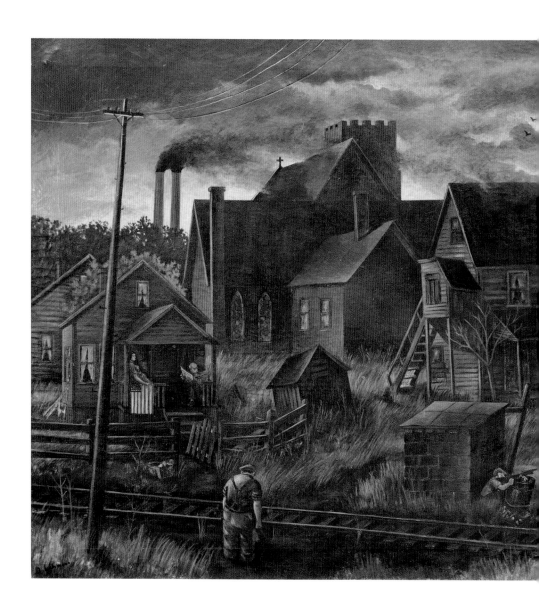

ARTHUR R. LEHMANN (American, 1913–1988)

Delray District—Detroit, 1938

Oil on canvas

26 × 34 in.

Gift of the Lehmann Family, 2014.2

THIS PAINTING most closely reminds me of where I grew up in southwest Detroit, surrounded by industry on all sides: the Ford Rouge plant, Marathon Oil refinery, and the Crystal (salt) Mines. Near where I lived is the Delray neighborhood, an area that became isolated due to the concentration of industrial factories and warehouses. In this painting, smokestacks contribute pollution to the already darkened sky. In the foreground a man with a lunch pail faces the train tracks that slash through the backyards of dilapidated houses. A U.S. flag is draped on the porch where a pregnant woman sits and an old man reads a newspaper. A young man points a gun toward a rusted-out car on blocks. A large, red brick church centers the composition but is swallowed up by the darkness around it.

Bronx-born and Detroit-raised, Arthur Lehmann worked in a variety of media during an artistic career that spanned five decades. A graduate of Cass Technical High School in Detroit, he furthered his education at various Detroit art academies. He was greatly moved by the struggle of the common man and the impact of the labor movement, which is reflected in this work. Though he joined the Works Progress Administration and worked on various commissions, eventually he accepted a position at General Mills as an illustrator in order to support his family.

John Rogers Cox (American, 1915–1990)

Nocturne—Silver and Grey, 1952

Oil and tempera on Masonite

17 × 23⅞ in.

Gift of Pat Glascock and Michael D. Hall in memory of all American Regional artists,

Inlander Collection, 2003.22

How artists handle night scenes is fascinating to me, but add in a storm, and things get even more interesting. The moon is half full on this field in Indiana, with just enough light to illuminate the clouds, haystack, and tree stump. Lightning has just struck in the distance, and the artist makes you feel the barometric pressure change as the skies are about to open. The tree stump looks like an alien landed in the wheatfields.

John Rogers Cox, born in Indiana, eventually moved to Chicago where he taught at the Art Institute of Chicago and painted for two decades. Cox is known for his magical-realist landscapes like this work. Perhaps he was also influenced by the 1950s fascination with sci-fi and alien movies and comics. As a fan of the fiction of Ray Bradbury, who portrayed Midwest American life in an eerie fashion in such works as *Something Wicked This Way Comes* (1962), I see the potential for something weird in this painting.

This painting is from a collection of 105 works known as the Inlander Collection. This collection comprises artists working in the early to mid-twentieth century in the Great Lakes region, including Michigan, Ohio, Indiana, Illinois, New York, Wisconsin, and Minnesota. The Inlander Collection was amassed by Pat Glascock and Michael D. Hall. Many of their works were donated or are on loan to the FIA through the Isabel Foundation, a Flint family foundation.

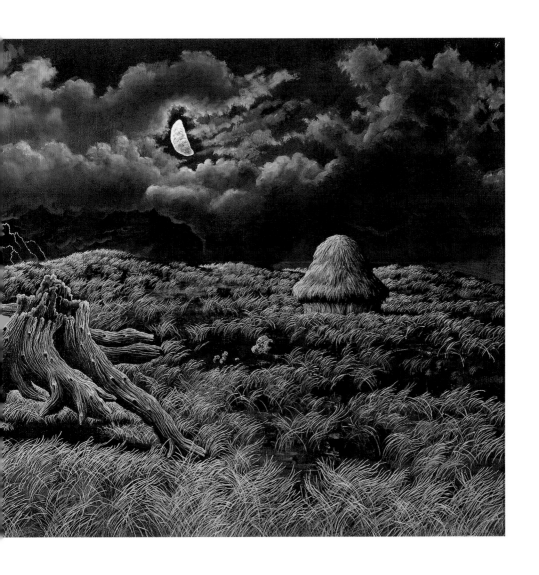

EDMUND LEWANDOWSKI (American, 1914–1998)

Spirit of Cultural Development, 1958
Industrialization of Flint, 1958

Venetian glass and cement

123 × 161 in.

117 × 216 in.

Commissioned by the College and Cultural Committee of Sponsors, 2005.54 (bottom), 2005.55 (top)

AFTER INHABITING FOUR DIFFERENT LOCATIONS around the city, the Flint Institute of Arts moved to the newly created Flint Cultural Center in 1958, along with other cultural and educational institutions. Several artists were commissioned to create works for the new building, including two large mosaic murals by Wisconsin artist Edmund Lewandowski. Though you might not guess by looking at the finished murals, Lewandowski was inspired by a visit to the large assembly plant for Buick (named "Buick City" in the 1980s) in the northeast of Flint. There are no cars depicted in the mural, but through energetic lines and colors, Lewandowski suggests the fast-paced forward momentum of the invention that would change the lives of everyone in the world, especially in the city of Flint.

Flint, originally a city where carriages were made, became the home of General Motors (GM) in 1908. Many of the FIA's generous benefactors as well as legacy families in Flint have direct or indirect ties to the automobile industry and its related entities. While GM generated much wealth for some, for others there was a different outcome. In 1999, the Buick City plant was closed, and thousands lost their jobs. However, in this mural there are no signs of this harsh economic reality yet to come; it instead represents a moment of celebration and an optimistic view of the future. In this artwork, Lewandowski underlines his belief that "our machines are as representative of our culture as temples and sculpture were to the Greeks. They are classically beautiful and represent physically the material progress the nation has made."

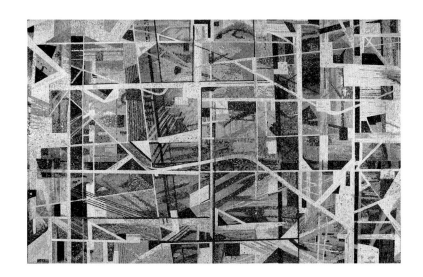

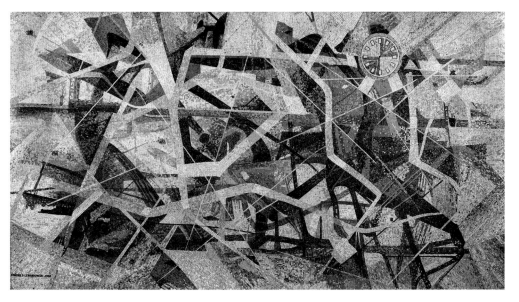

CHAKAIA BOOKER (American, born 1953)

India Blue, 2001

Rubber tires and wood

73 × 43 × 38 in.

Bequest of Russell J. Cameron, by exchange, and partial gift from the

Friends of Modern Art, 2002.11

ARTISTS HAVE THE UNIQUE ABILITY to transform everyday, ubiquitous objects and materials to help us see things in a new way. They help us to rethink our world, to make the familiar look strange. In this case, New York–based artist Chakaia Booker turns tire rubber into a sculpture that looks like it could be alive, a fantastical creature that has just manifested in the museum. Known for her tire sculptures, Booker has earned the nickname "Queen of Rubber Soul." Born in Newark, New Jersey, Booker moved her studio to downtown Manhattan where, in the 1980s, the streets were filled with discarded trash and remnants of industrial materials. She would collect tires and rubber she found, eventually making it her primary material.

Visitors react to this work primarily by wanting to touch it. There's something about its flowing, spiky presence that makes people want to have a physical connection with it, to touch it to make sure it's real.

I remember a chance meeting with the artist on the streets of Chelsea in 2014, and after a brief conversation she agreed to come to Flint to talk about this sculpture. The following year, she participated in a Q and A when her work was featured in *Common Ground: African American Art from the Flint Institute of Arts, the Kalamazoo Institute of Arts, and the Muskegon Museum of Art.*

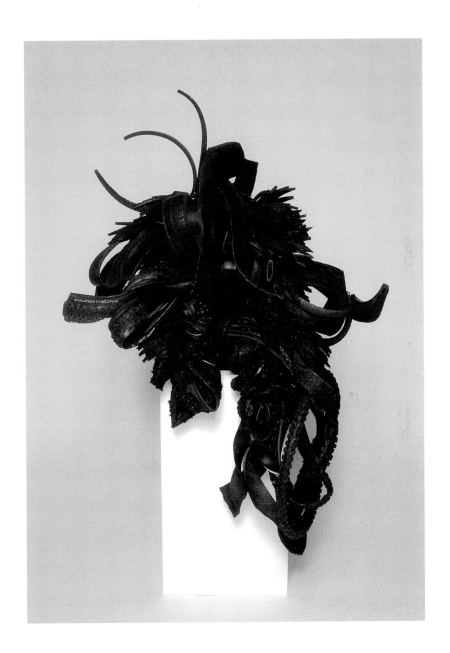

KARI RUSSELL-POOL (American, born 1967)

Daisy Chain, 2004

Flameworked glass
16 × 12 × 12 in.
Gift of Claire White, 2005.17

FLAMEWORKED GLASS, created with a handheld torch, is often used on a smaller scale to create jewelry, beadwork, and paperweights. In this sculpture, Kari Russell-Pool pushes the boundaries of the medium. This glass sculpture combines delicacy and strength, fragility and power.

Inspired by the classical form of a Greek trophy, or amphora, American artist Russell-Pool transforms the ancient shape into her own personal expression. Suffering from an undiagnosed illness that prevented her from doing ordinary tasks, she decided to focus her artistic endeavors on what she had already achieved. To do so, she created a series titled *Trophies* to commemorate both large and small victories in her life. She writes, "The work is autobiographical, and although objects are my vehicle, I think of them as self-portraits as each series reflects the timely concerns of my life."

This work was given to the FIA by Claire White, a philanthropist, ceramic artist, and granddaughter of Charles Stewart Mott. Mott served on the General Motors board of directors from 1913 to 1973 and started the charitable foundation that bears his name in 1926. Through the family's efforts, several artworks have been given and many long-term loans have been made to the FIA, including 147 works of glass from the Isabel Foundation. The Isabel Foundation was founded by Charles Stewart Harding Mott in the name of his wife Isabel (Claire's father and mother). The Foundation looks for programs that embody the spirit of Isabel: she loved grace, youth, art, energy, freshness, and the beauty of healing.

Deborah Butterfield (American, born 1949)

Tarkio, 2011

Bronze

96 × 101 × 50 in.

Gift of the Hurand Family and museum purchase fund, 2011.131

Visitors usually react to this sculpture with surprise and delight when they find out it is not made of driftwood but bronze. My own response is amazement at how the artist can make tough, rigid materials evoke the sense of a living horse.

American artist Deborah Butterfield first selects wood to sculpt the horse, attaching the pieces to a metal armature for the overall shape. Once complete, the wood is labeled and dismantled so that a mold can be made for each piece. Bronze is poured into the mold, and once cooled it is then reassembled. The final step is an application of chemicals to recreate the look of driftwood.

Butterfield has long been attracted to depicting horses in her work, claiming her birth on the seventy-fifth running of the Kentucky Derby as primary inspiration. She has stated that horses act as a type of self-portrait: "I first used the horse images as a metaphorical substitute for myself—it was a way of doing a self-portrait one step removed from the specificity of Deborah Butterfield."

This sculpture was commissioned for the FIA in 2011 by the Hurand family. Art and Bess Hurand were supporters of the FIA for many years, especially Bess who served as a docent for decades. Together they saw another small sculpture by Butterfield that was on loan to the museum and felt that it would be good for the FIA to have one of its own. I was fortunate to be here when *Tarkio* was unveiled in the Hurand Sculpture Courtyard.

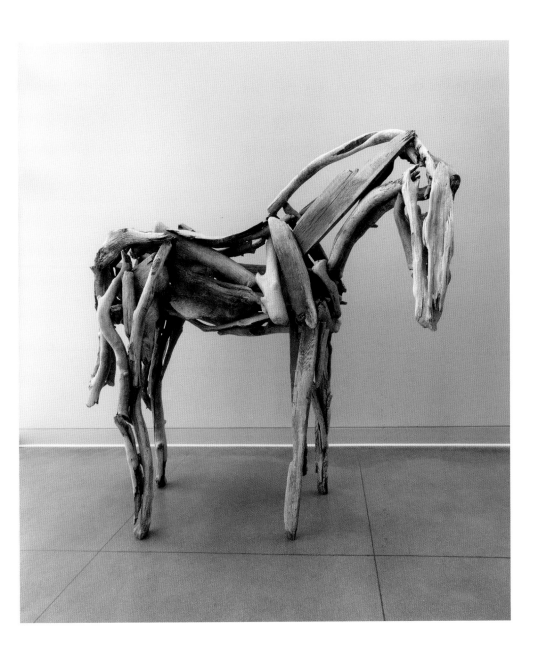

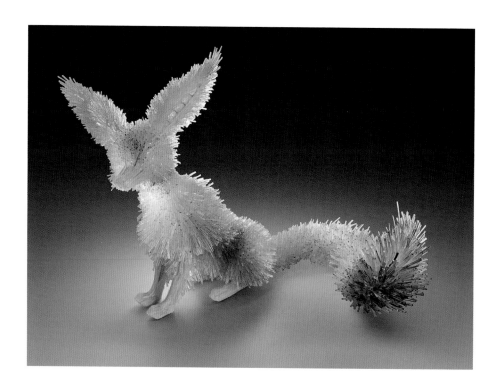

Marta Klonowska (Polish, born 1964)

Fenek, 2011

Glass

20 × 36 × 20 in.

Museum purchase with funds from Mr. and Mrs. Thomas Lillie and the Sheppy Dog Fund,

Dr. Alan Klein, Advisor, 2016.1

At first glance, this fox looks cute and cuddly, with spright ears and a bushy tail. When you look closer, however, you would be wise to stay clear of this animal made of shards of broken glass. Polish artist Marta Klonowska's primary subject matter is animals. She starts with a drawing and then creates a three-dimensional metal frame covered in wire mesh. She cuts panes of glass into small shards that are then glued to the frame to become the animal's body and fur. In this sculpture, she has depicted a fennec fox, a small nocturnal animal found in the Sahara. Their unusually large ears radiate body heat to help keep them cool in the desert.

When visitors are asked about their favorite work in the museum, this fox is usually named, which delights me. When I first saw this work at Habatat Gallery in Royal Oak, Michigan, it seemed like a perfect fit for the FIA collection. It "lives" in the gallery dedicated to contemporary glass, with works by sixty-eight artists from fourteen countries. Among more traditional methods of glassmaking, such as casting and blowing glass, this work stands out, demonstrating how artists continue to explore the medium in interesting ways.

Irina Zaytceva (Russian, born 1957)

Twins, 2013
Porcelain
10¾ × 7¼ × 3⅜ in.
Gift of Dr. Robert and Deanna Harris Burger, 2021.226

While in the form of a teapot, this porcelain work is hardly functional. It depicts an imaginary scene under the sea—conjoined-twin mermaids hold flutes against a gold background. Their tail forms the handle, and a delicate lace of coral takes the place of a nonexistent spout. The back of the vessel continues the fantastical narrative, with fish morphing into humans and a head emerging out of a nautilus shell. With this whimsical imagery, it might not be surprising to learn that Russian artist Irina Zaytceva is also a children's book illustrator.

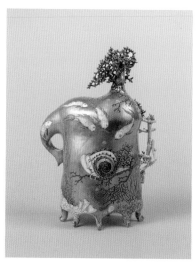

Aside from the aesthetic delight of the vessel's wrap-around scene, this work is a tour de force of technical achievement. The work is hand-sculpted, and the image was applied after it was glazed and fired. Zaytceva paints with overglaze enamels made of metal oxides mixed with finely ground glass that bind to the existing glaze in a technique known as porcelain or china painting. Each color must be painted and fired before the next layer is added. The last glaze to be applied is the gold—the artist must be precise so as not to overlap any of the other painted work. This time-consuming process requires patience and a careful hand to achieve the desired result.

This work, along with 378 other ceramics, was donated to the FIA by Dr. Robert (Bob) and Deanna (Debbie) Harris Burger. The Burgers have been collecting contemporary ceramic works of art since the 1970s. Debbie has ties to Flint, having enjoyed ceramic classes at the Flint Institute of Arts in her youth. Ceramic classes continue to be the most popular; the Art School uses more than twenty-five tons of clay each year.

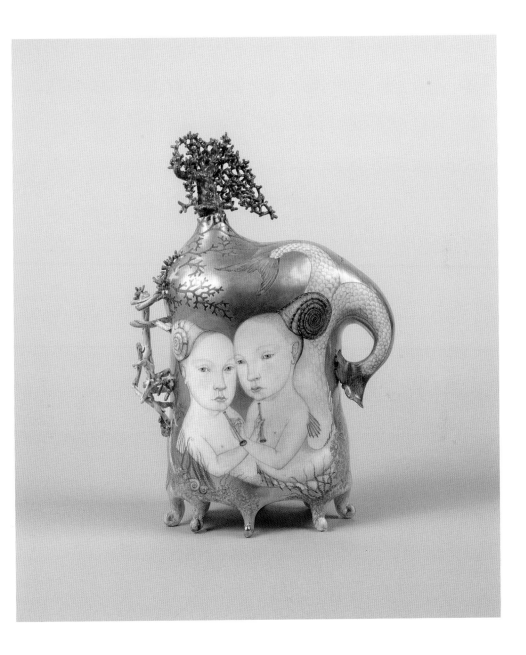

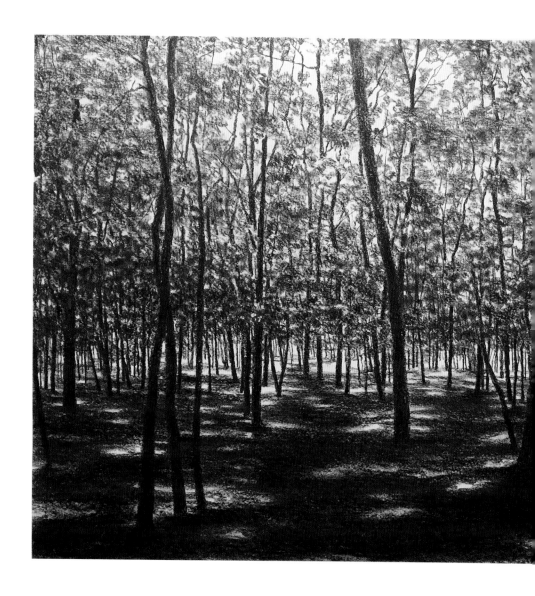

APRIL GORNIK (American, born 1953)

Forest Light, 2014

Lithograph on paper
20 × 27 in.
Commissioned for the Flint Print Club, 2014.45

WITH JUST BLACK INK AND WHITE PAPER, American artist April Gornik creates the powerful effect of bright sunshine breaking through treetops to the forest floor. The maze of trees, leaves, and shadows becomes a lacelike pattern that communicates depth and mystery. Though she is now known for her large-scale landscape paintings, in her early career she wanted to pursue conceptual art. According to the artist, "I've had an abiding interest in light and open space since I was a kid—I always felt better being outside than inside. I seem to have a deep impulse to reach out spiritually and emotionally to what's furthest from me."

Gornik was commissioned by the FIA to create this lithograph for the Flint Print Club in 2014. The Flint Print Club was started in 2007 as a membership initiative to provide information about printmaking and collecting. Since its inception, the club has commissioned fifteen prints by artists including Janet Fish, Hunt Slonem, and Chakaia Booker, to name a few.

This work is among the more than 4,500 works on paper—including prints, photographs, watercolors, and drawings—in the FIA collection. They are available to view online or in person by appointment in the Piper Print Library.

DESIREE KELLY (American, born 1990)

Shields, 2018

Oil and spray paint on traffic sign

35 × 35 in.

Museum purchase with funds from the Collection Endowment, 2019.13

DETROIT ARTIST DESIREE KELLY is known for her mixture of "street art" and traditional oil portraits. Kelly approached me for the possible acquisition of this painting, and after seeing her work in person, I knew it would be a great addition to the collection. During her graphic design studies at Wayne State University in Detroit, Kelly was introduced to oil painting and embraced it enthusiastically. In her chosen medium, Kelly paints portraits of public icons, reflecting on the narrative of her subjects by including artifacts or phrases within each piece.

This Speed Zone Ahead sign is painted with the portrait of Claressa "T-Rex" Shields, the American professional boxer who reigned as the female middleweight champion of the world from 2019 to 2020. Shields, born in Flint, is one of only seven boxers in history, male or female, to hold all four major world titles in boxing simultaneously. She won gold medals in both the 2012 and 2016 Olympics, making her the first American boxer to win consecutive medals.

I like how this work combines both Detroit and Flint. My hometown is Detroit, but my career has brought me to Flint. Both cities have difficult and turbulent histories, dealing with economic and social challenges. But in both you see the resilience and spirit of the communities, who with hard work, determination, and grit get though the most difficult times.

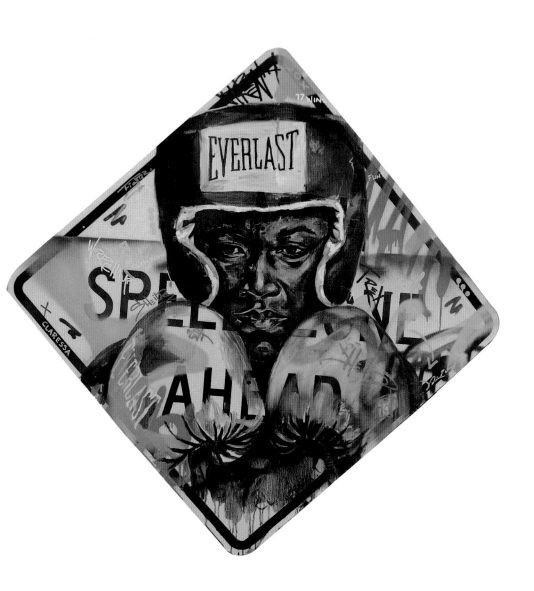

Ed Watkins (American, born 1950)

Preach Turner, Matthew 13:46, 2019

Mixed media on paper

38 × 28 in.

Museum purchase with funds raised from the Community Gala, 2022.3

Flint native Ed Watkins depicts a powerful moment in a sermon by Dr. Rabon Turner, pastor of Grace Emmanuel Baptist Church in Flint. The message on that day, May 19, 2019, was based on a parable taught by Jesus, as recounted in the Gospel of Matthew: "Again, the kingdom of heaven is like a merchant in search of fine pearls, who on finding a pearl of great value, went and sold all that he had and bought it" (Matthew 13:45–46).

Watkins, a printmaker, draftsman, and retired arts educator, often receives inspiration for his artwork during church services. He starts with taking notes, sketching, and shooting photographs, and then reflects on what he's heard and experienced to create a work later. According to the artist, "I like the atmosphere of my church on Sunday morning … and how we usher in the spirit."

In the summer of 2021, I visited Watkins's studio and collaborated with him to select works for his first solo exhibition at the FIA in 2022. This work was on view along with others from the *Preacher* series that he created during the first months of the COVID-19 pandemic. These works represented for him the hope people felt.

Preach Turner was purchased with funds raised by the Community Gala, a diversity initiative that annually raises funds to add works by African American artists to the FIA's collection.

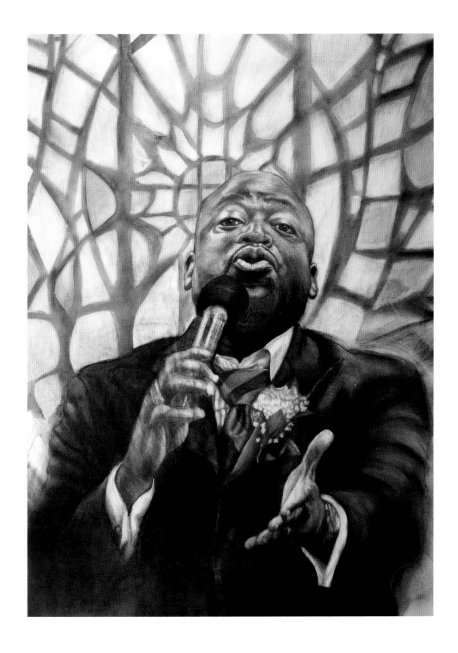

This book was made possible by the Whiting Foundation and Trustee Linda LeMieux. The Whiting family has been integral to the success and history of the Flint Institute of Arts, contributing many great works of art and financial support.

This edition © Scala Arts Publishers Inc. in collaboration with Flint Institute of Arts

First published in 2023 by
Scala Arts Publishers, Inc.
c/o CohnReznick LLP
1301 Avenue of the Americas
10th Floor
New York, NY 10019 USA
www.scalapublishers.com
Scala—New York—London

In association with
Flint Institute of Arts
1120 East Kearsley Street
Flint, Michigan 48503-1915
www.flintarts.org

Distributed outside of Flint Institute of Arts in the book trade by
ACC Art Books
6 West 18th Street, Suite 4B
New York, NY 10011 USA

978 1 78551 526 2
10 9 8 7 6 5 4 3 2 1

Editor: Kati Woock
Design: Patricia Inglis, Inglis Design
Printed and bound in China

Director's Choice is a registered trademark of Scala Arts and Heritage Publishers Ltd.

Library of Congress Cataloging-in-Publication Data: Names: Tracee J. Glab , author | Title: Director's Choice: Flint Institute of Arts, Michigan, in association with Scala Arts Publishers, Inc. New York. Description: Executive Director Tracee J. Glab discusses thirty-seven of her favorite works of art, including paintings, drawings, prints, and sculpture, from the collection of the Flint Institute of Arts in this edition of Director's Choice. Identifiers: LCCN 2023940581 | ISBN 978 1 78551 526 2 (pbk.). Subjects: Art. Museums. Flint Institute of Art.

Unless noted below, all photographs are © Flint Institute of Arts; frontispiece, pp. 52–53: reproduced with permission of the Charles E. Burchfield Foundation; p. 25: Douglas Schaible Photography; pp. 40–41, 48–49, 54–55: © 2023 Artists Rights Society (ARS), New York; p. 69: © 2023 Deborah Butterfield / Licensed by VAGA at Artists Rights Society (ARS), NY

FRONT COVER:
Mary Cassatt (American, 1844–1926), *Lydia at a Tapestry Frame* (detail), ca. 1881. Oil on canvas; 25⅝ × 36⅜ in. Gift of the Whiting Foundation, 1967.32.

FRONTISPIECE:
Charles E. Burchfield (American, 1893–1967), *Nighthawks at Twilight* (detail), 1917–49. Watercolor on paper; 34⅜ × 48½ in. Gift of the Viola E. Bray Charitable Trust, 1964.3.

BACK COVER:
Desiree Kelly (American, born 1990), *Shields*, 2018. Oil and spray paint on traffic sign; 35 × 35 in. Museum purchase with funds from the Collection Endowment, 2019.13.